Travel the World Adult Coloring Book

Anti-stress Coloring Book for Adults

Relax and Unwind Coloring Book for Adults
10 Stress Relieving Locations Around the World

by Hauk Coloring Books for Adults

Legal Notice:

The author and publisher of this book have used their best efforts in preparing this book. The author and publisher make no representation or warranties with respect to the accuracy, applicability, or completeness of the contents of this book. The information contained in this book is strictly for educational purposes. Therefore, if you wish to apply ideas contained in this book, you are taking full responsibility for your actions.
The author and publisher disclaim any warranties (express or implied), merchantability, for any particular purpose. The author and publisher shall in no event be held liable to any party for any direct, indirect, punitive, special, incidental or other consequential damages arising directly or indirectly from any use of this material, which is provided "as is", and without warranties.

COPYRIGHT HAUK BOOKS ALL RIGHTS RESERVED

Contents

North America	5
England	7
Australia	9
Italy	11
South America	13
India	15
Japan	17
Africa	19
Austria	21
France	23

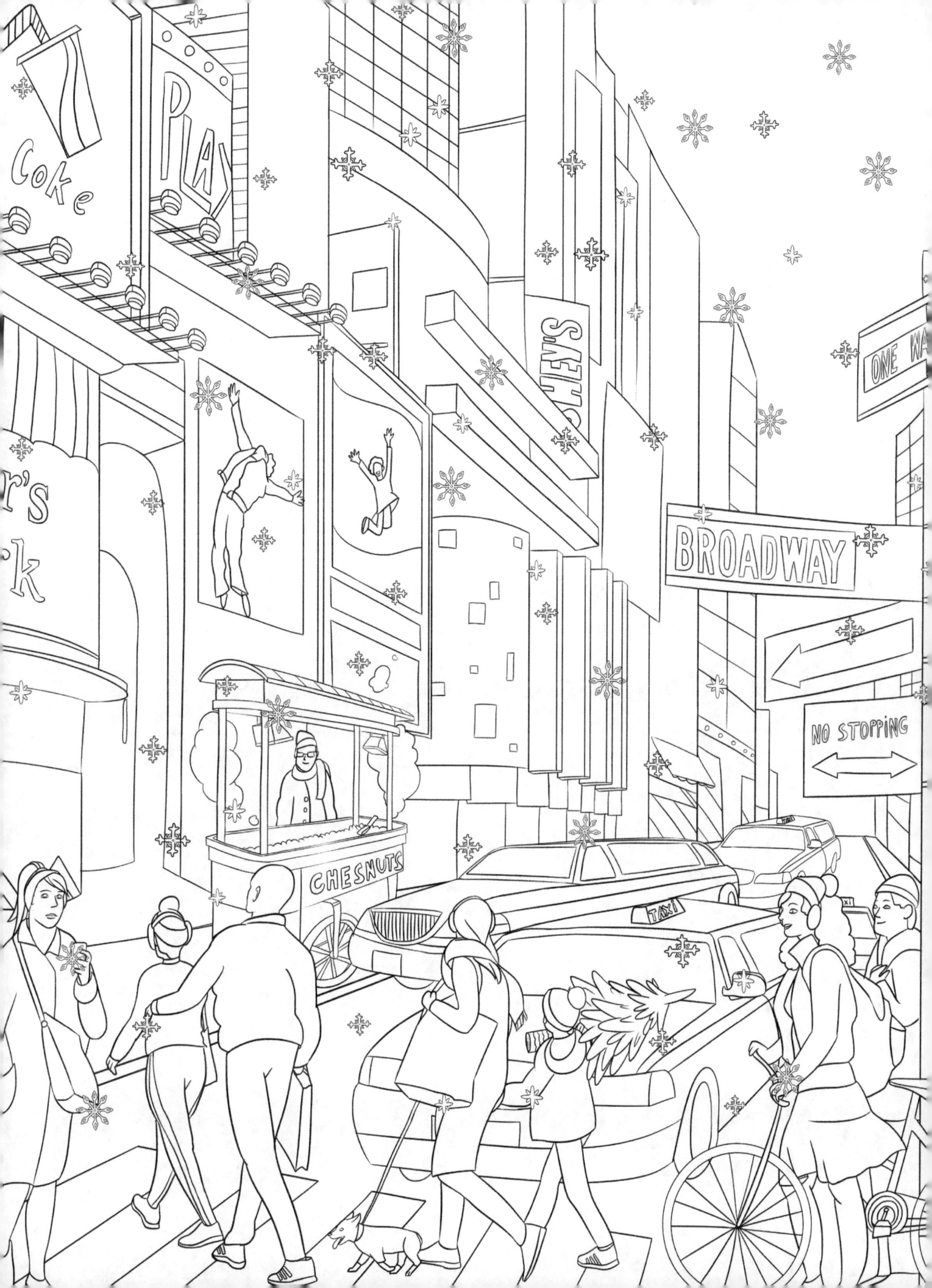

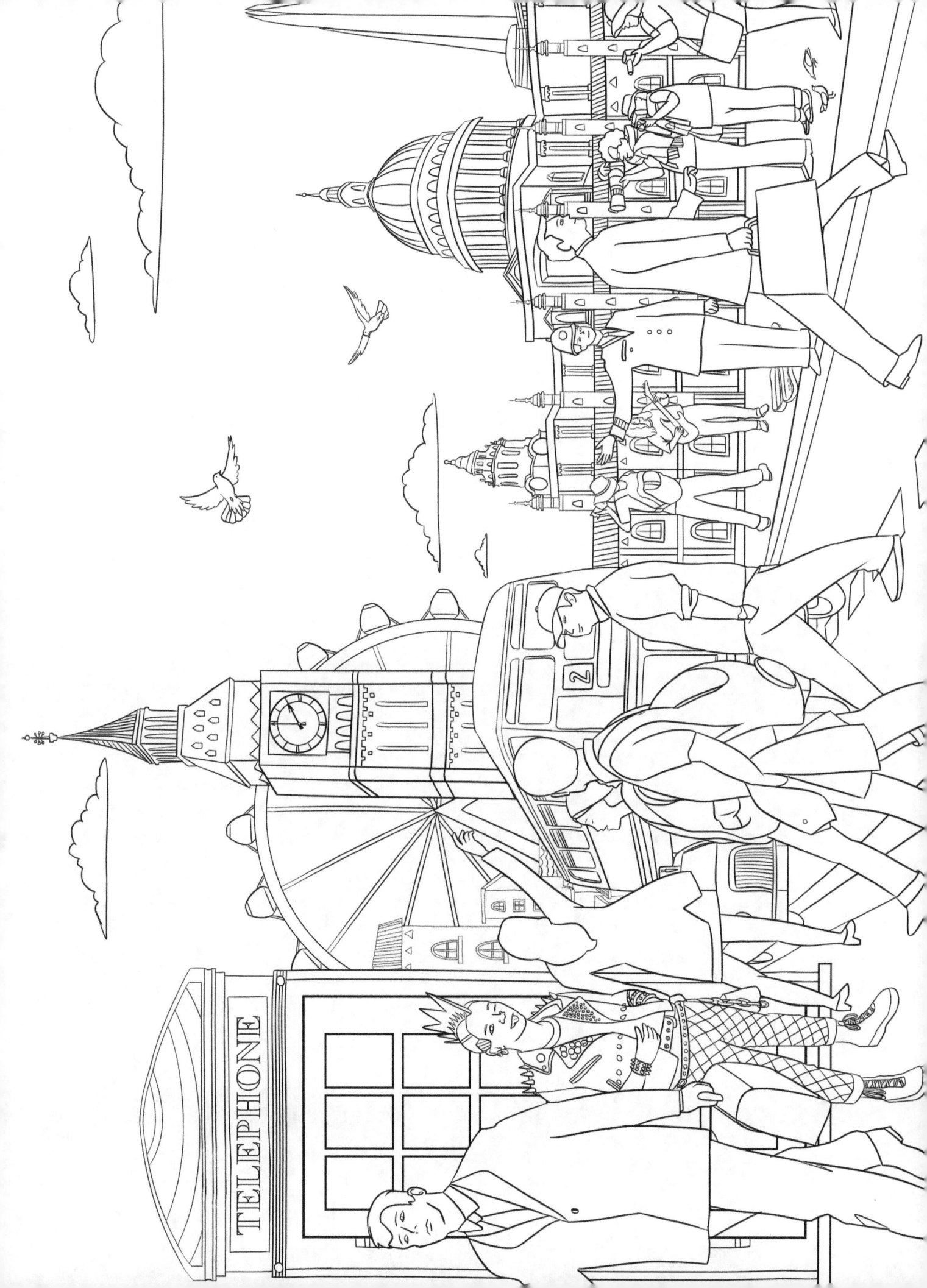

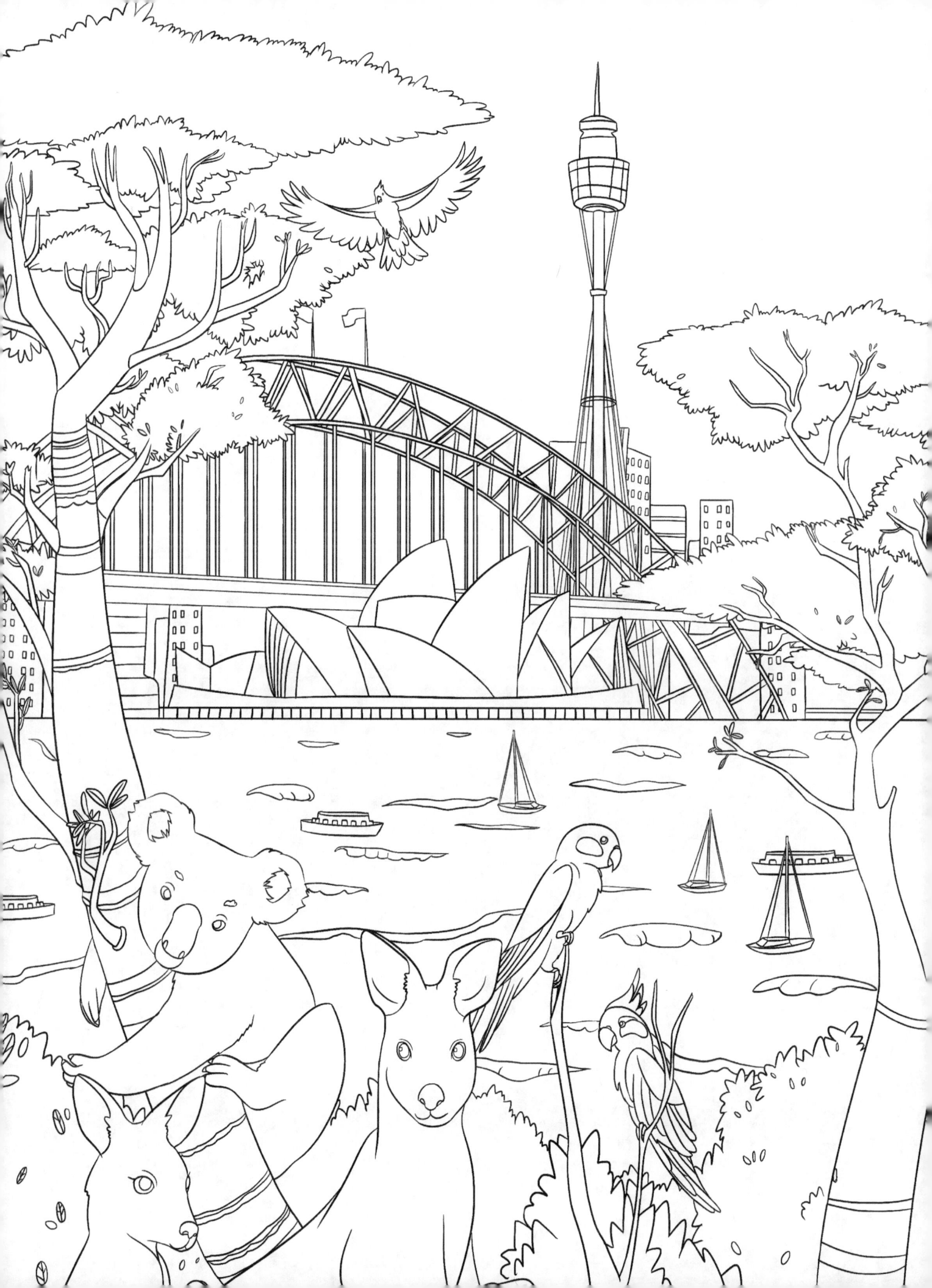

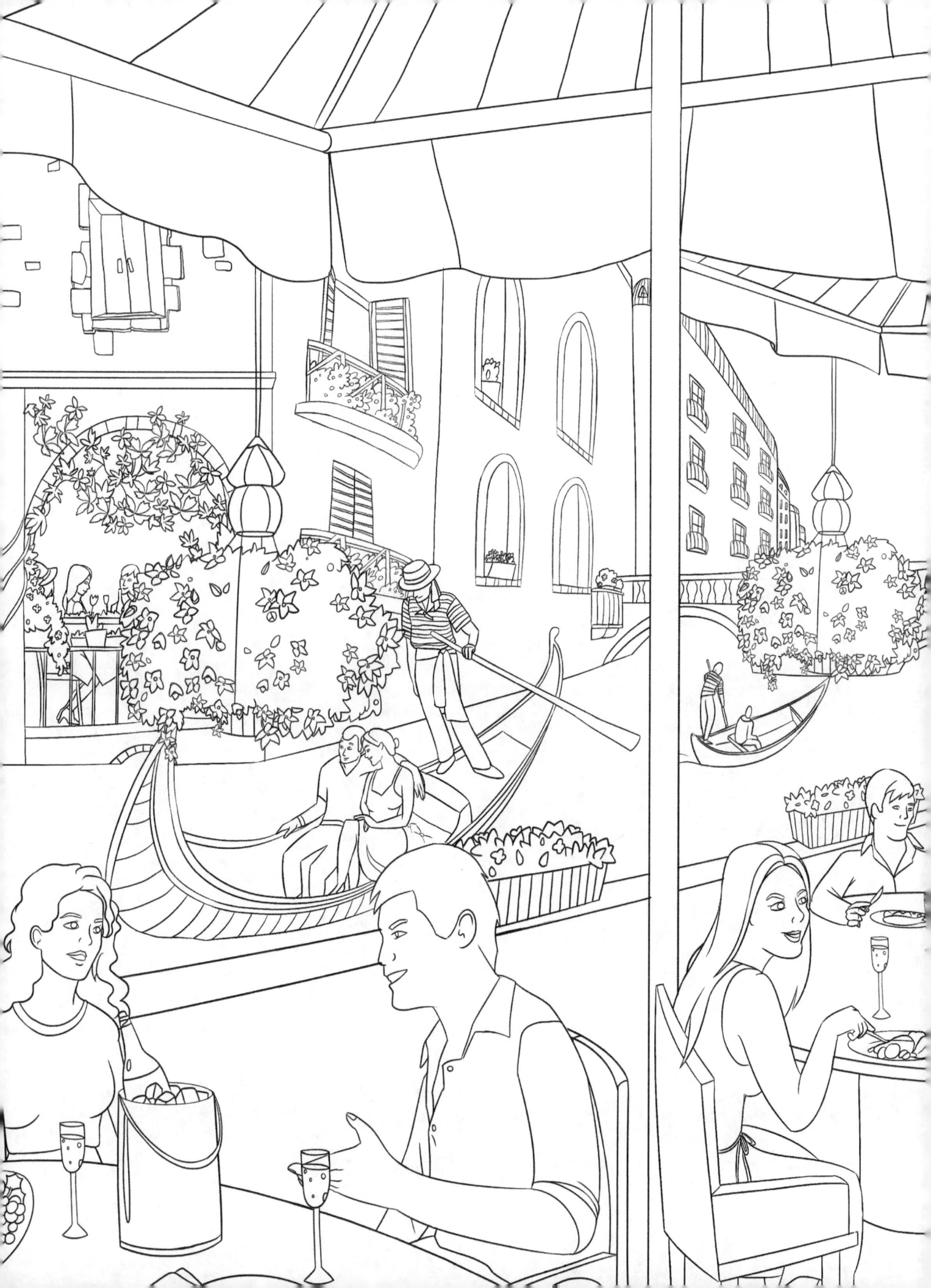

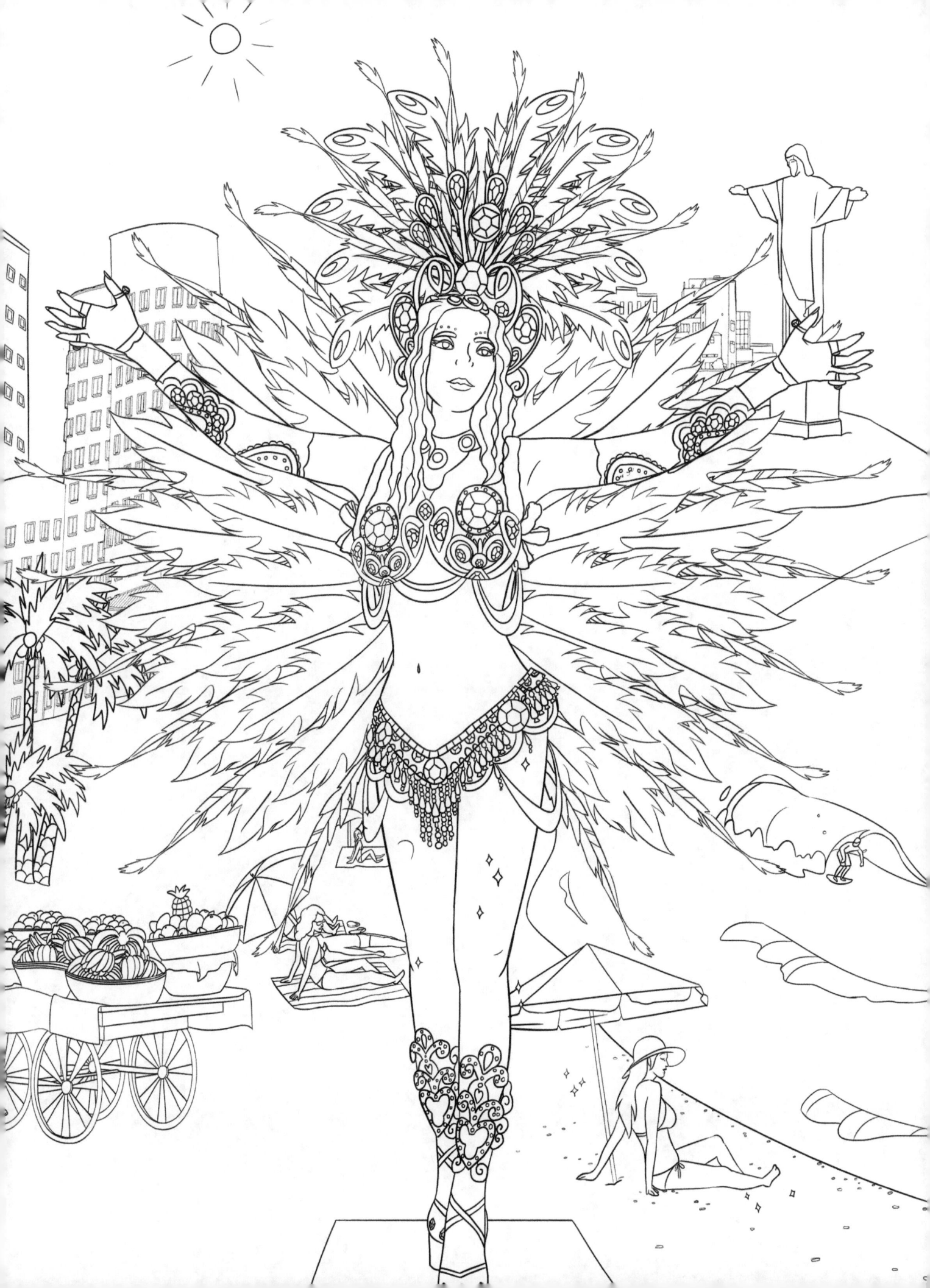

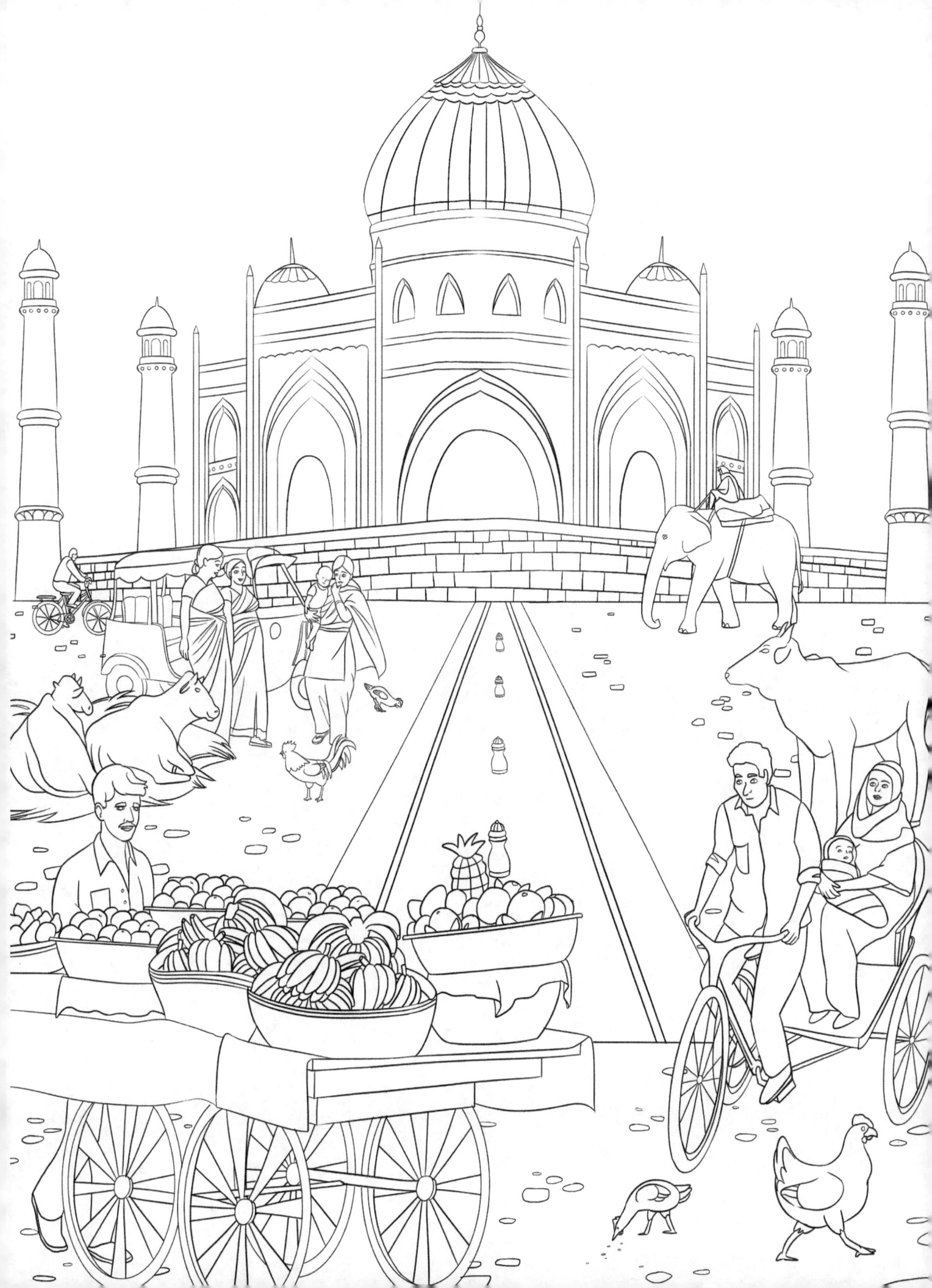

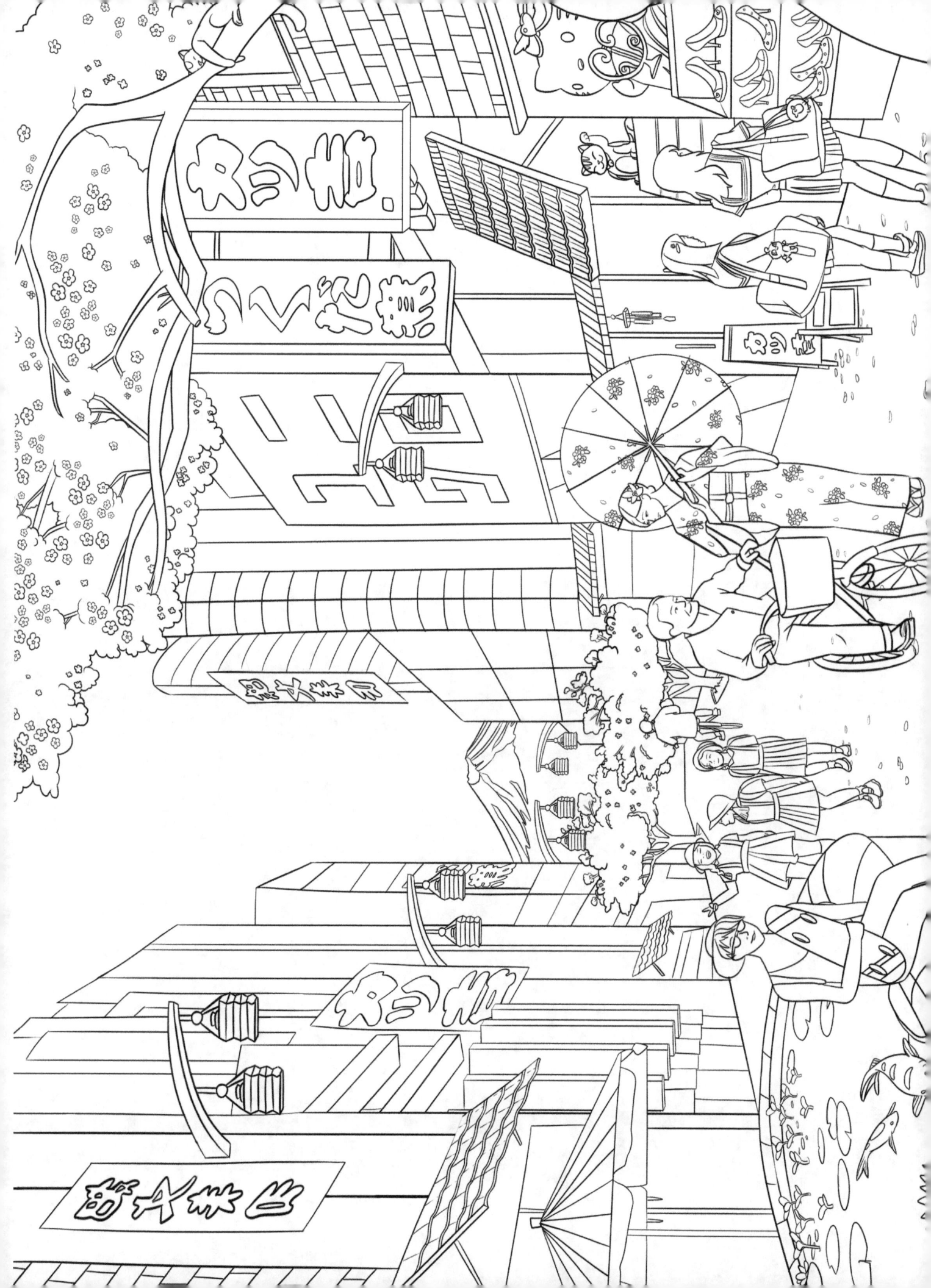

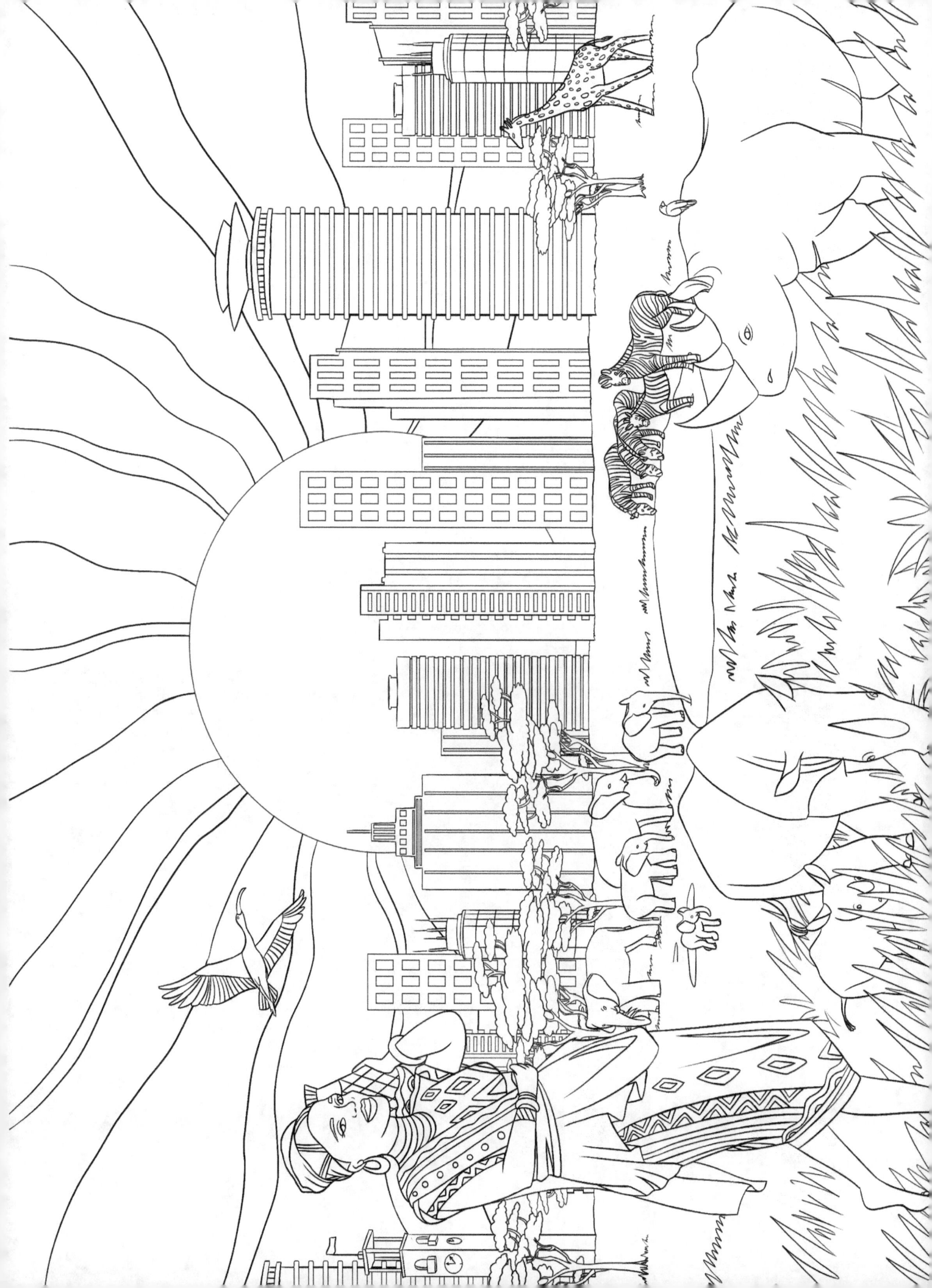

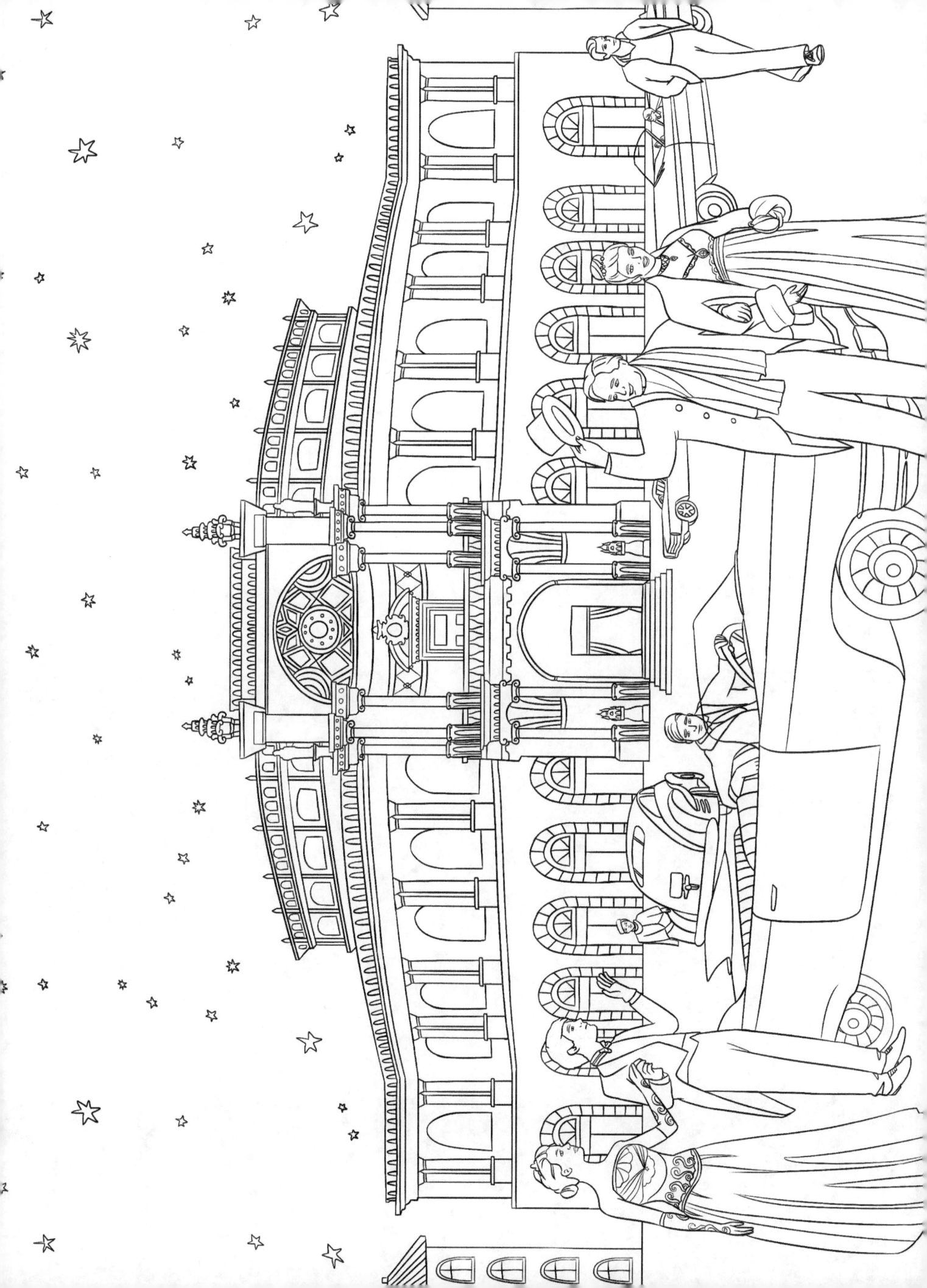

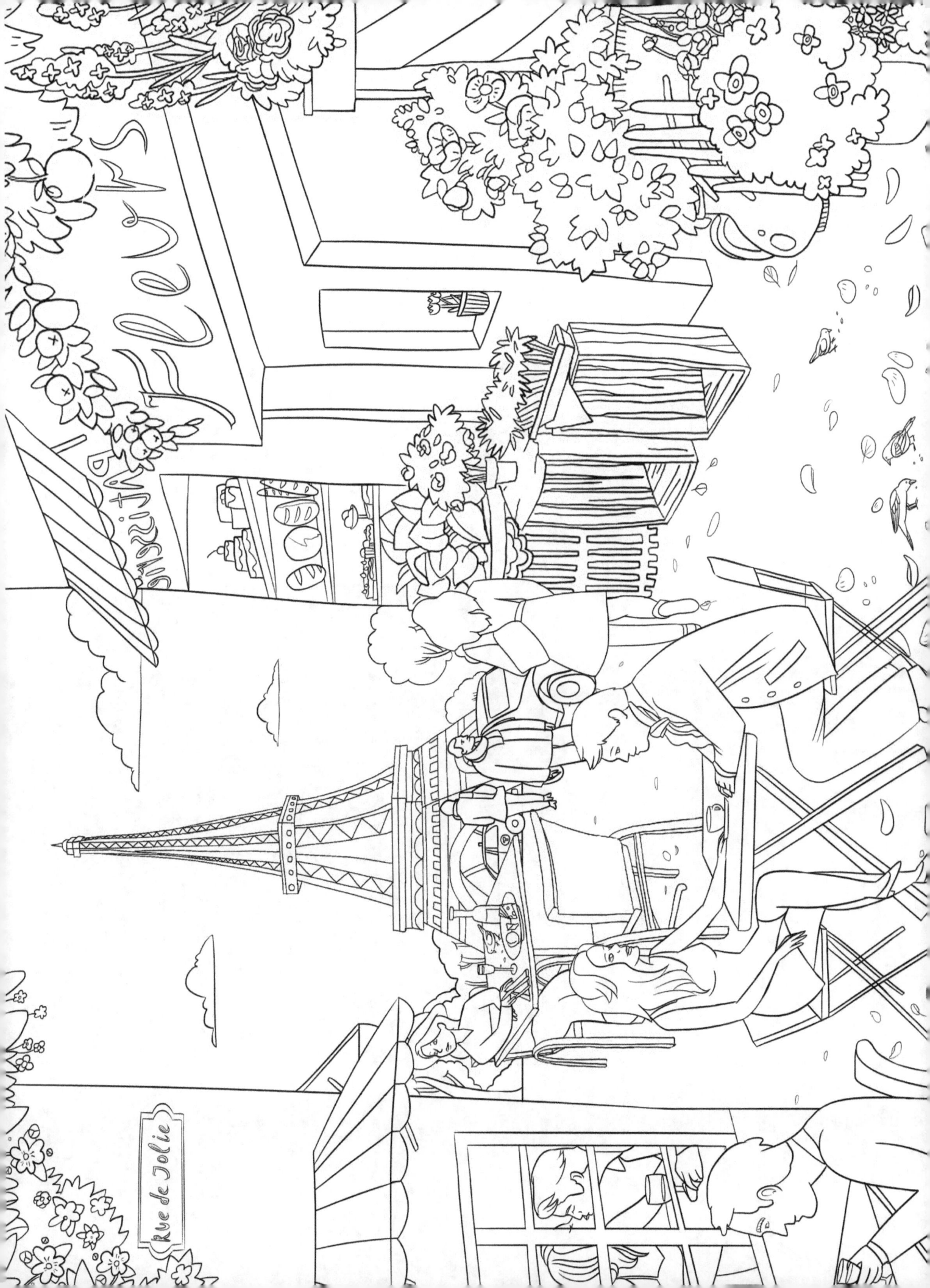